CHILDISH THINGS

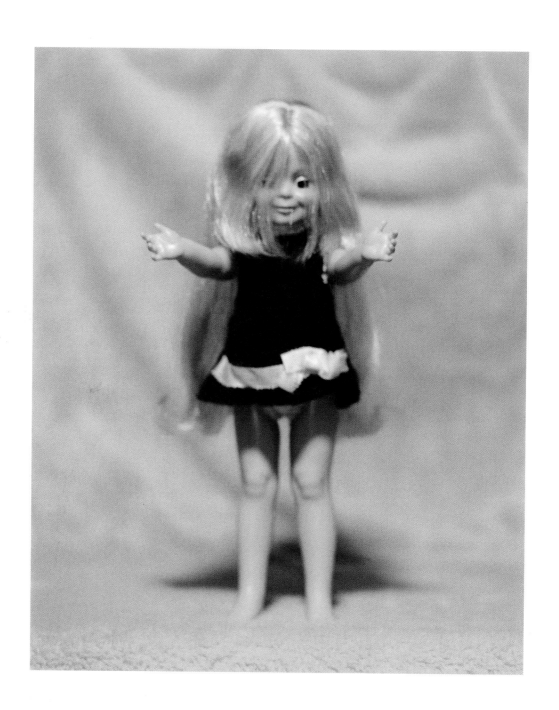

plate 1 **Krissy**

PHOTOGRAPHS BY DAVIS & DAVIS

INTRODUCTION BY TYLER STALLINGS

CHILDISH THINGS

SANTA
MONICA
PRESS

Published by:

SANTA MONICA PRESS LLC
P.O. Box 1076
Santa Monica, CA 90406
1-800-784-9553
www.santamonicapress.com
books@santamonicapress.com

Printed in China

Santa Monica Press Books are available at special quantity discounts
when purchased in bulk by corporations, organizations or groups.
Please call our Special Sales department at 1-800-784-9553.

Library of Congress Cataloging-in-Publication Data

Davis, Denise, 1959-
Childish things / by Davis & Davis ; introduction by Tyler Stallings.
p. cm.
ISBN 1-891661-43-4
1. Photography, Artistic. 2. Toys--Pictorial works. 3. Davis, Denise, 1959- 4. Davis, Scott, 1954- I. Davis, Scott, 1954- II. Title.
TR655.D38 2004
779'.092'2--dc22
2004000453

Davis, Denise & Scott
Childish Things / Photographs by Davis & Davis
Introduction by Tyler Stallings

ISBN 1-891661-43-4

"When I was a child, I spoke as a child, I understood as a child, I thought as a child: but when I was grown, I put away Childish Things."

—I Corinthians xiii 11

THOSE WHO HAVE MANAGED TO SAVE A FAVORITE TOY from childhood know that a kewpie doll, a teddy bear or a plastic soldier can be a prodigious storehouse of fond memories. Just as cherished toys recall the joys and warmth of a happy childhood, so lost and abandoned toys retain repressed memories of prepubescent trauma and the deep-seated guilt associated with the playing of forbidden games.

While abandoned toys are rejected outright, lost toys represent something evicted from consciousness as in a Freudian slip. Either way, the result is the same: the contents of the childish unconscious at large in the world. As found in parking lots, on sidewalks, or in thrift stores, these toys lack meaningful context and purpose—a situation we attempt to correct.

For this series we stage mini-psychodramas on miniature sets with the toys portraying the conflicted children who left them behind. We then photograph the resulting tableaus with a shallow focus that suggests the bleary selectivity of memory. By these means, we hope to achieve for the conflicted, former toy-owners a measure of catharsis by proxy.

Davis & Davis

DESIGN: Diptychs, triptychs and quadriptychs are shown as double-page spreads of like-sized photographs. Odd-sized photographs on opposite pages are related thematically. Polaroids represent earlier versions of the photographs with which they are paired.

PHOTOGRAPHS: All photographs in Childish Things are editioned, chromogenic prints (except where noted) and were shot in Los Angeles between 1995 and 2003 using toys found in California, New Hampshire, and Cornwall (England). The photograph of the artists on page 96, *If a Man/Woman Answers,* is from the *Modern Romance* series by Davis & Davis. For more information, exhibition news and to see other work by Davis & Davis, visit www.davisanddavis.org.

**The authors gratefully acknowledge the contributions
of the following individuals:**

Heather Marx & Steve Zavattero
Christine Jaspers
Mark Greenfield

Craig & Jolene Myers
Ed & Judy Nygren
Joel Glassman
Ted Meyer

Elinor H. & John R. Davis
Olga Fishcoff Carrasquillo & Charles H. Carrasquillo

The Everyday Lives of Childish Things

by Tyler Stallings

LITTLE BOYS AND GIRLS play make-believe regularly. It's one way of learning the good and the bad of what the world will offer as they grow. But what if their imagined scenarios seem tainted: a little girl in a kitchen with a teacup of spilled bleach, a baby in the mouth of an alligator, or a blue boy standing in a puddle of waxy, red blood? What kind of lessons are they learning? The collaborative team of Denise & Scott Davis, otherwise known as Davis & Davis, would like to know. They play with dolls to this day as an attempt to re-enact that psychological state when the rules of society are just beginning to be acquired. In their hands, these playthings are painstakingly staged, lit, and are given impossible and animated poses, with the aid of gossamer wires, all done in an effort to suggest a special but perverse moment in the real lives of real toys.

Davis & Davis use neither Barbie nor Troll dolls. Rather, they employ a range of discarded, thrift-store-bound figurines. They are made from a range of materials—rubber, wood, ceramic, and plastic—and their origins range from the early twentieth century to the present. Hardly any of them hold a place in our popular imagination; they have been forgotten. But Davis & Davis reinvigorate them with their own creepy yet funny episodes, like the evil-minded ventriloquist dummy in the movie *Magic* or the doll, beloved by little boys, though possessed by a murderous spirit, in the movie *Chucky*. Similarly, Davis & Davis's synthetic and pliable thespians seem almost life-like when we experience them as larger-than-doll-size photographs.

But why have toys stand in for real people? The artists do so in order to get at the heart of why subtle shifts in behavior can be so disturbing, whether acted out or staged for a photograph—one way or the other, reality or artifice, each alternative requires a dose of the other in order to be accomplished.

The universal aspect of toys is that they feel like archetypes as a result of their stylization. They would appear to come from some higher source rather than a manufacturer's

imagination. And yet, despite their power as ideals, they are powerless, like a child, able to be manipulated in the sadistic hands of its owner. It is this contradictory message of innocence and transgression inherent in a toy, and in the everyday life of its owner, that motivate Davis & Davis to create alarming but seductive images.

THERE ARE DOLLS who are adult players in some of their scenarios, but children always play the central roles. In the book's lay-out, the artists suggest a timeline from birth, to toddlerhood, to adolescence, moving from purity, to corruption, to a recognition that such moralistic classifications are actually meaningless.

The book leads off with *Major Tom* (plate 2), which depicts a toy astronaut weightless in outer space, and whose air hose suggests an umbilical cord—though it is severed and unconnected to a mother. Here, the book's somber side is set: achievement is accompanied by alienation, mankind is alone in the universe, and reaching for the stars may be mankind's downfall. However, the use of toys here and throughout always reminds us that the power of play is the opportunity to act out fears in the safety of one's imagination.

This image is followed by *Piss Baby* (plates 4 & 5), a clever reference to Andres Serrano's controversial *Piss Christ*. Here, the baby floats in a pool of urine, as if in utero, but it is also an early indication of how Davis & Davis challenge the myths of innocence that surround motherhood, childhood, and their connections to religion. As the family evolves together, Davis & Davis present a polyptych of four images titled collectively, *The Ralphs* (plates 20–23). Dad, Mom, Sis, and Baby are each shown hunched over a toilet presumably turning their family's last name into a verbal pun. The complexities of sexual awakening come later in works such as *Bend Over Boy* (plate 39). A young man, still fully clothed, bends over at a ninety-degree angle, as only a toy can, his butt being presented to someone offstage. His face looks at us the viewer, possessing an expression that wonders if he's doing the right thing, seeking guidance from us. Both subject and viewer are helpless though. The boy lacks a mouth to communicate and we viewers are powerless while we stand on the other side of the looking glass.

Later, viewing sex as both a time for joyful play and also a moment when power relations are explored, the artists present the triptych, *Bendy Bunny (Anal, Oral & Genital)* (plates 53–55). Again, Davis & Davis give a nod to another artist, this time Robert Mapplethorpe,

who became mired in controversy in the late 1980s when previously approved federal funding was yanked for a show of his photographs that depicted sadomasochistic acts with a clinical eye. The three works also allude to Sigmund Freud's categorization of our sexual development. This is the crux of Davis & Davis's *Childish Things* projects: the desire to defy categories within the context of a society that tends to classify in order to attempt to fulfill a mythological goal of clear-cut morality.

Candy (plate 61) is the last image in the book, behaving as a concluding summary of the complex desires expressed throughout these pages. Here we have an older child, who is naked, sports long blonde hair, and stands behind a curtain of plastic jewels that she parts with one hand. She seems to be living in an adult world though she is just a child, and just a toy. As viewers, we are attracted to the curtain of jewels, like candy, in spite of being reminded of the controversies that surround Nabokov's novel *Lolita* or photographer Jock Sturges depiction of unclad children in idyllic settings—portraits that are meant to celebrate life rather than represent predatory intentions. The image begs the viewer to ask the question that is a thread throughout the book: what are the complex relationships between the artists, the toy models, and the viewers?

IT IS THESE DIVERSE REALITIES that Davis & Davis aim to overlap upon one another when they spend hours turning a doll over in their hands, passing it back and forth between them, inspecting it like anthropologists, trying out various sacred-and-profane poses. During this process, they ask themselves: what is the doll trying to say beyond the original intentions of its manufacturer and designer?

Any answer to this question will be teeming with ambiguity. For example, in *Worm Girl* (plate 60), a Sleeping Beauty breed of doll stands on a chair against a luscious deep orange-red background, her back to the viewer, holding up the ends of her dress with her hands, her head tilted down at the floor, staring at a comparatively oversize inchworm with a cartoon-like smiley face. The scenario is playful and menacing. The woman, dressed like a princess, is either scared of the worm or is standing on the chair to escape it . . . or perhaps she lifts her skirt as an invitation to the worm, who, after all, does possess a wide and knowing grin.

Davis & Davis attempt to find the pose that appears like a natural response to the situation, whether sinister or saccharine. It is a staged photography that follows in the recent tradition

of artists who came to prominence in the early 1990s such as Jeff Wall, Gregory Crewdson, and Philip-Lorca diCorcia. These artists have taken their cues from previous photographers such as Garry Winogrand and Joel Meyerowitz's street photographs taken nearly thirty years earlier, or of Nan Goldin more recently. And even stretches back to the early twentieth-century granddaddy of the photographic decisive moment, Henri Cartier-Bresson. What all of these artists share in common, whether taking a snapshot from the hip on the street, or creating complicated, staged sets that require the equivalent of a film crew, is the desire to capture that instant when the subject stands in its most revealed condition.

At one time, photography was thought to be the medium which provided the most realism since it seemingly captured what was in front of a lens. Over one hundred years later, people generally accept the notion of the easy manipulation of photographs either digitally or more simply in regard to staging a scene. Despite a savvy public there is still an ironic desire on their part for a manipulated photograph to be imbued with a realistic immediacy, in order to suggest that the impossible event just occurred.

Bungee Baby (plates 17 & 18) exemplifies this contradictory desire within the broader cutting-edge, photo-based art community. In this work, the viewer is reminded of the staged quality by Davis & Davis's replacement of human actors with toys, as they do in all their work, but then they saturate the work with realism through their choice of poses and scenarios.

Here, a man in a business suit runs down the side of a suburban house with his arms outstretched, hoping to catch a baby that has seemingly been thrown out a window head first. Davis & Davis have ingeniously suspended the man just above the ground as both his legs leave the earth's surface just for an instant in his panic-stricken stride, and the baby is also in mid-air, having just been cast out by someone unknown. Despite the subjects being toys, our mouths are agape as we suspend belief long enough, believing that somehow a photographer was strolling along in this neighborhood of toys, heard the screams, hauled out his trusty extension of an eye, and snapped this deplorable scene.

But then outrage is thwarted because if you recall the title, the baby will bounce back into the safety of the home. It is like a Loony Tunes cartoon—*Bugs Bunny*, for example—which involves so much violence yet no one ever dies. The tumult is meant to be a platform for visual puns that adults will understand and also function as ingenuous gags that entertain the kids. It is this dual nature, this serious side of humor, that makes those cartoons and Davis & Davis's images so relevant and timeless.

The dark humor in Davis & Davis's comedies and tragedies follow in the tradition of photographers such as Diane Arbus and Joel Peter-Witkin. Arbus is best known for taking pictures of circus freaks and other people with unusual traits. Her photographs travel the fine line between exotic fascination with outcasts and conveying the complex interior life that any human possesses. Peter-Witkin comes from a more Surrealist tradition. Throughout his career Witkin has photographed hermaphrodites, dwarfs, amputees, and body parts borrowed from morgues. He positions his subjects as a theatrical tableau, feeling no fault at playing up the abnormalities, but he cannot be judged as being insensitive because it is evident that his subjects have chosen to play along. No one involved, photographer or model, feels any shame about the obviousness of the aberrant body parts.

Like many artists who explore the darker side of humanity, Davis & Davis are not doing so for shock but rather as a process by which to help us, the viewers, become sensitive to how we project notions onto the world and how we portray ourselves to others. They want us to question our childhood, our adulthood, our idealizations, and our sense of humor. Like their predecessors, perhaps Davis & Davis want to make sure to deflate the cherished myth of innocence, reminding us that no one is really that untainted and sinless, whether photographer or model, adult or child.

plate 2 **Major Tom** >

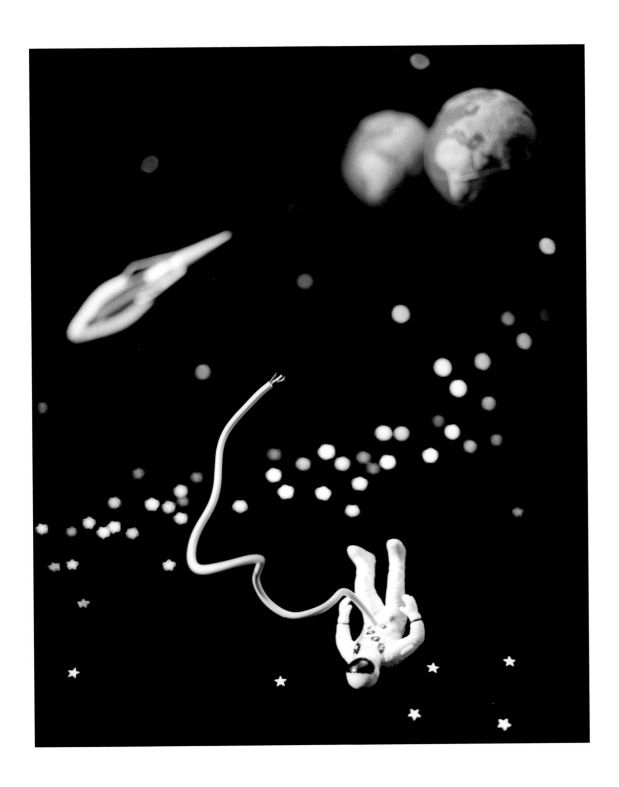

plate 3 **Tong Baby** >

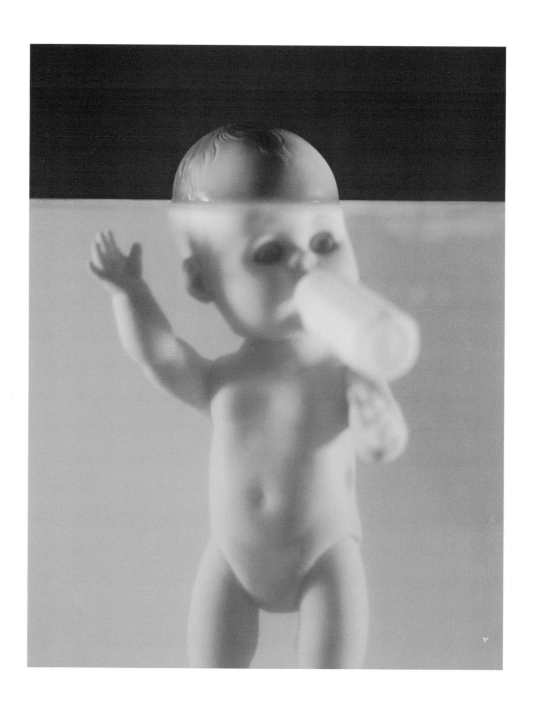

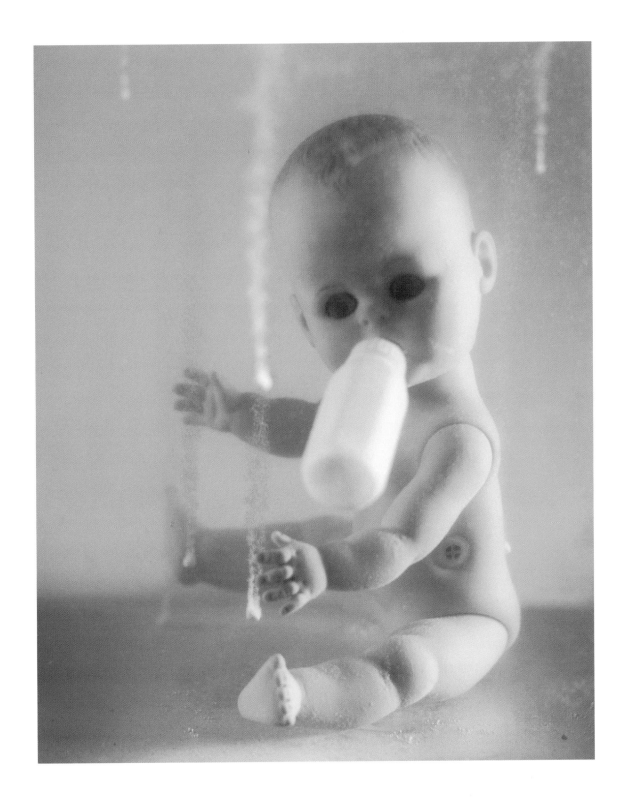

plate 6 **Cocoa Baby** >

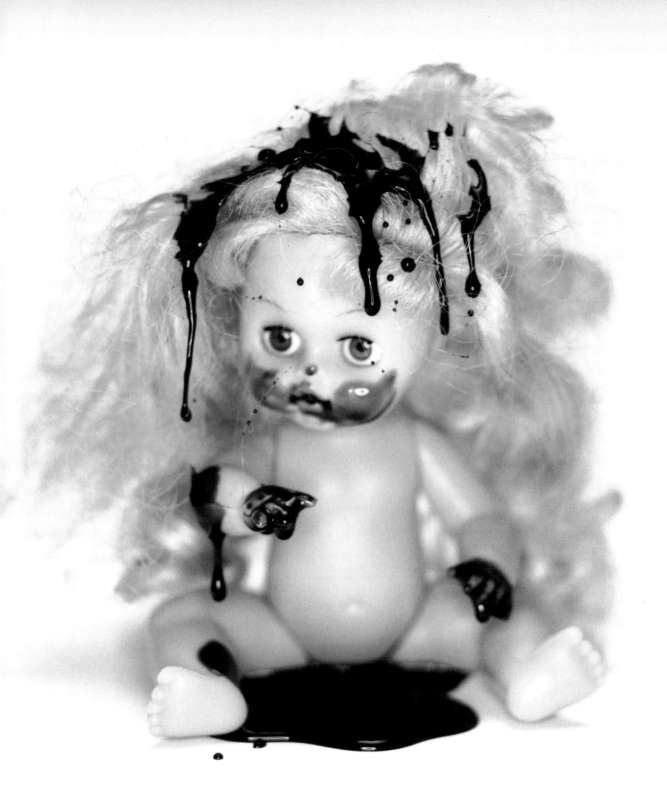

plate 7 **Gator Baby** >

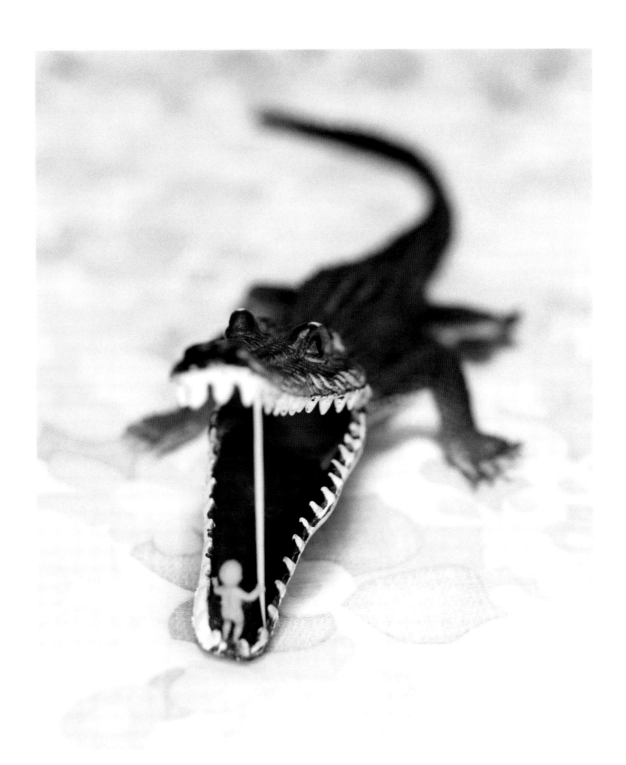

plate 8 **Block Baby** (Polaroid)
plate 9 **High Chair Baby** >

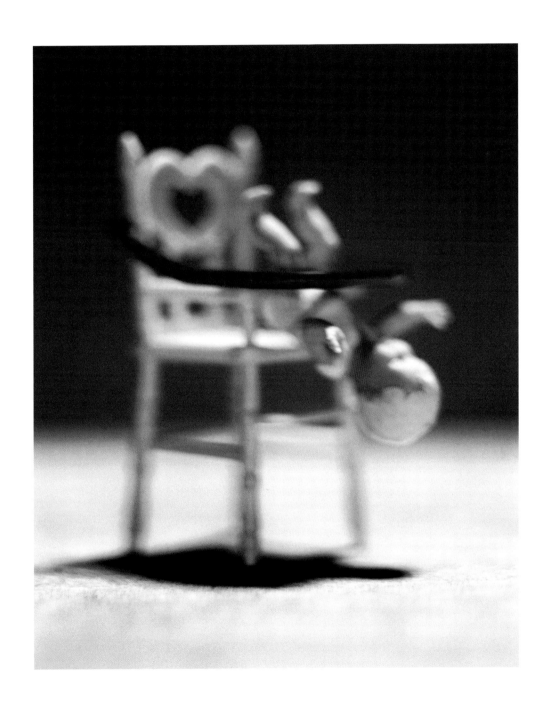

plate 10 **Snow Baby** >

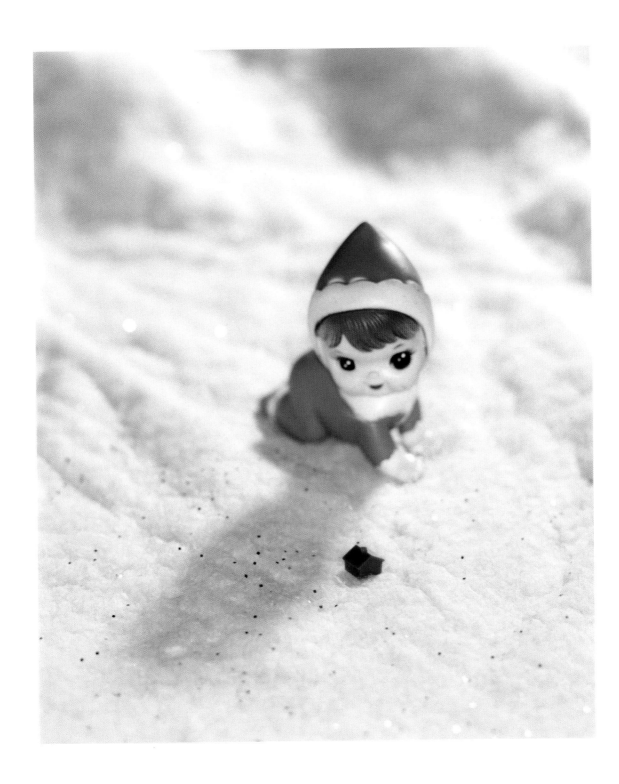

plate 11 **Spool Baby** >

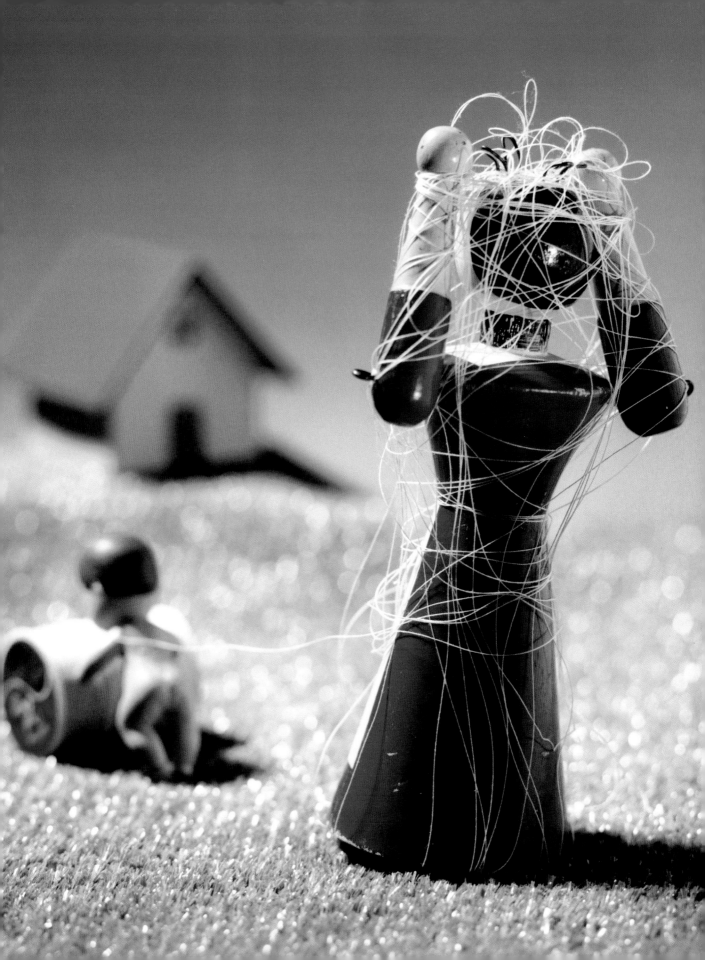

plate 12 **Bow Wow Baby, version 1** (Polaroid)
plate 13 **Bow Wow Baby** >

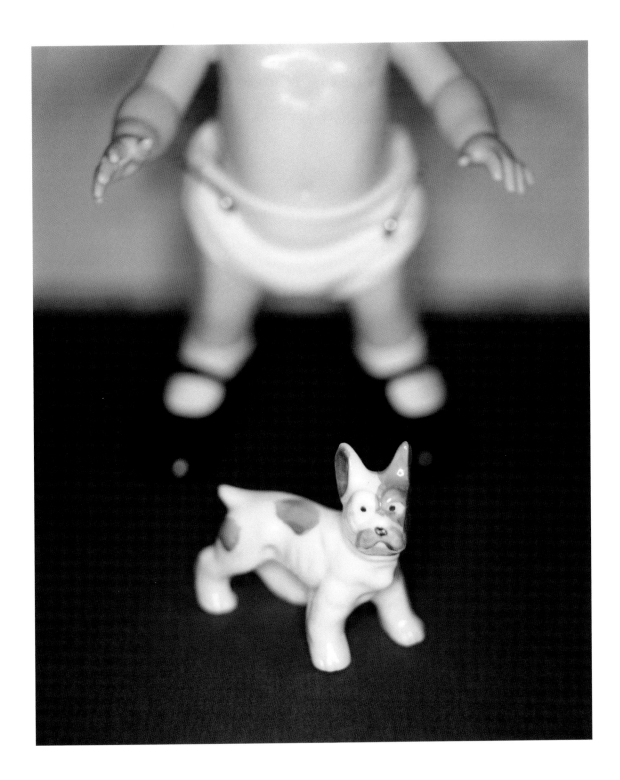

plate 14 **Teeter Tot** >

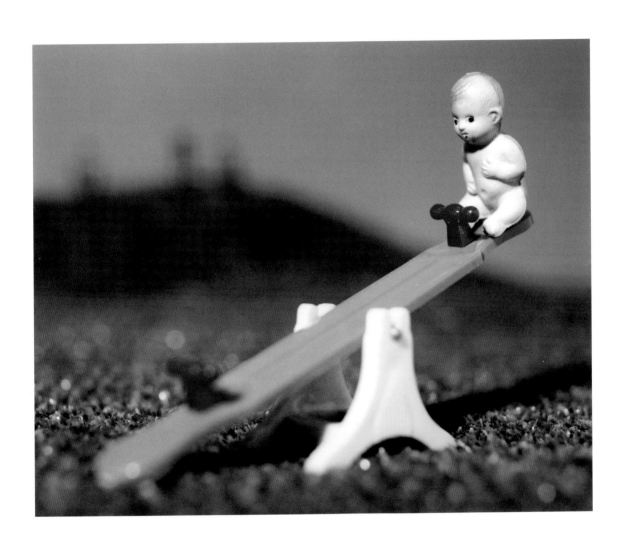

plate 15 **Harold Angel** >

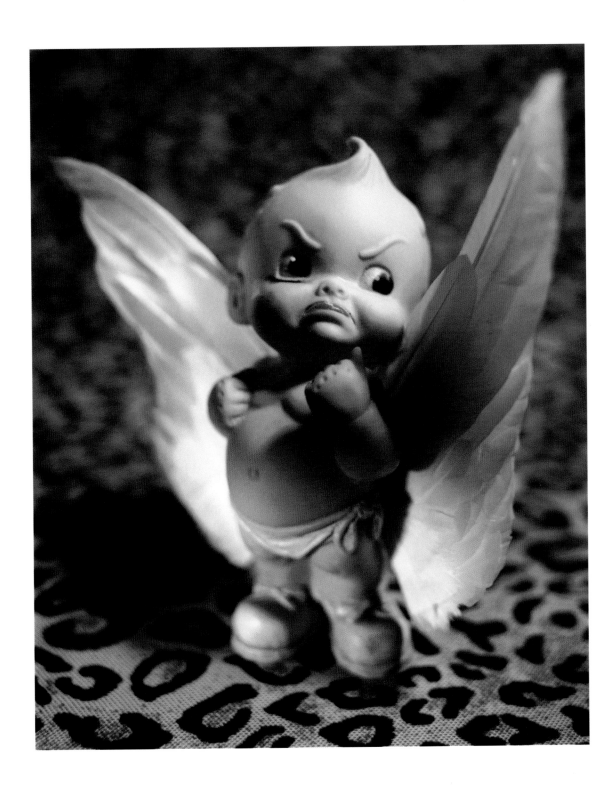

plate 16 **Cry Babies** >

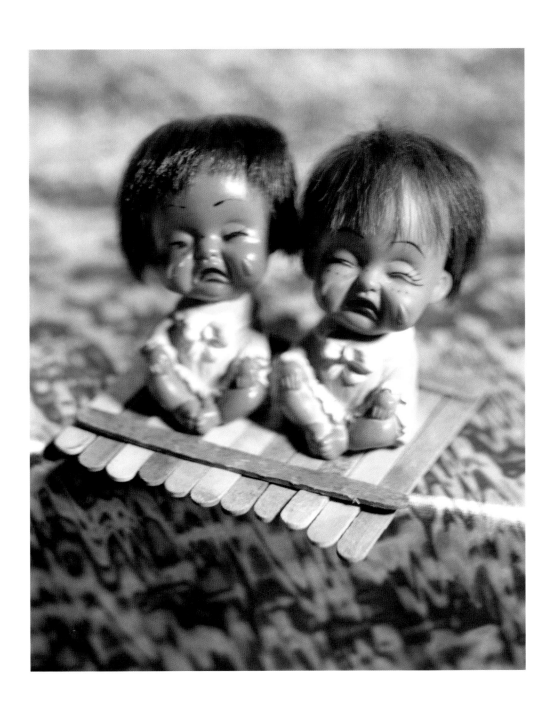

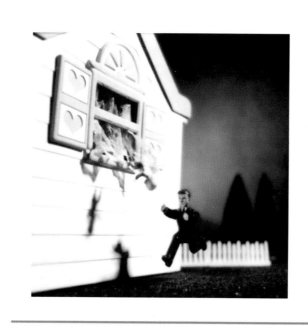

plate 17 **Bungee Baby, version 1** (Polaroid)
plate 18 **Bungee Baby** >

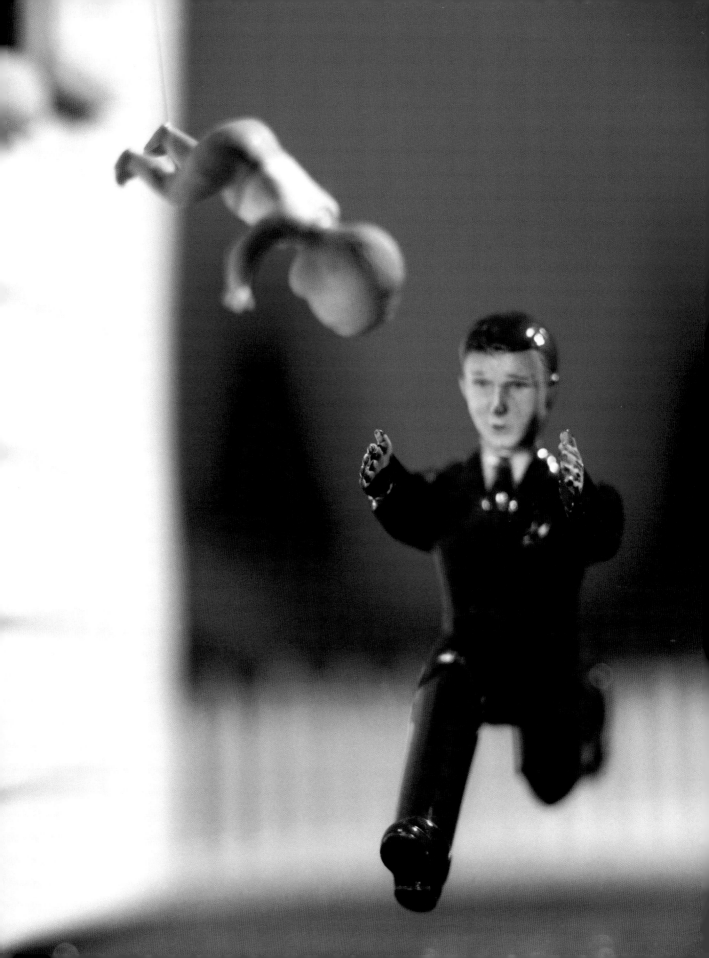

plate 19 **Piano Baby** >

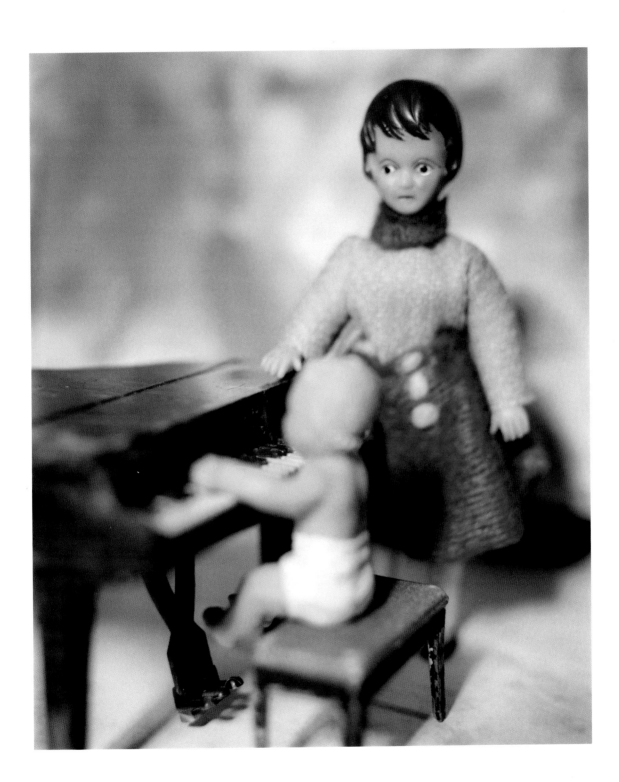

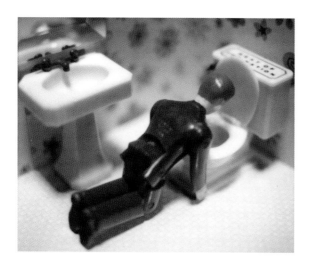 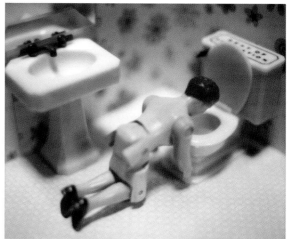

plates 20 - 23 **The Ralphs** (quadriptych)

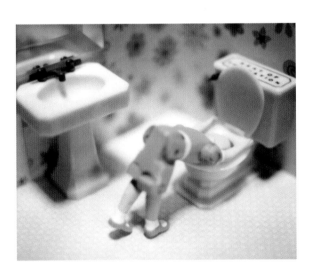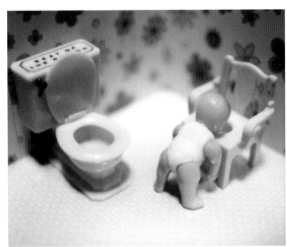

plate 24 **Candle Boy** >

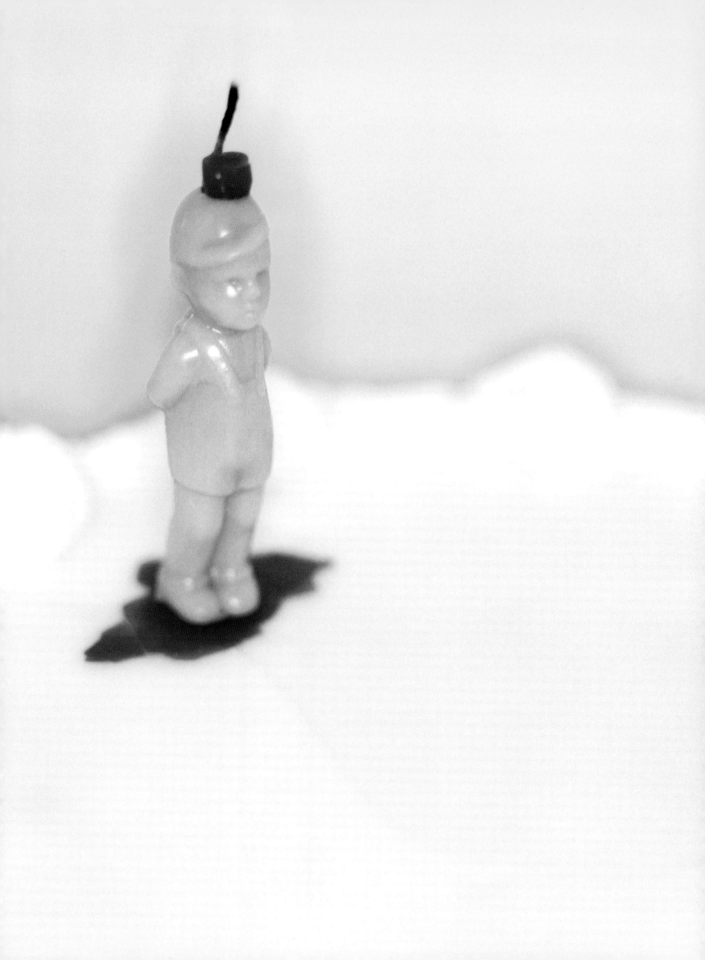

plate 25 **Beginner Swimmer** >

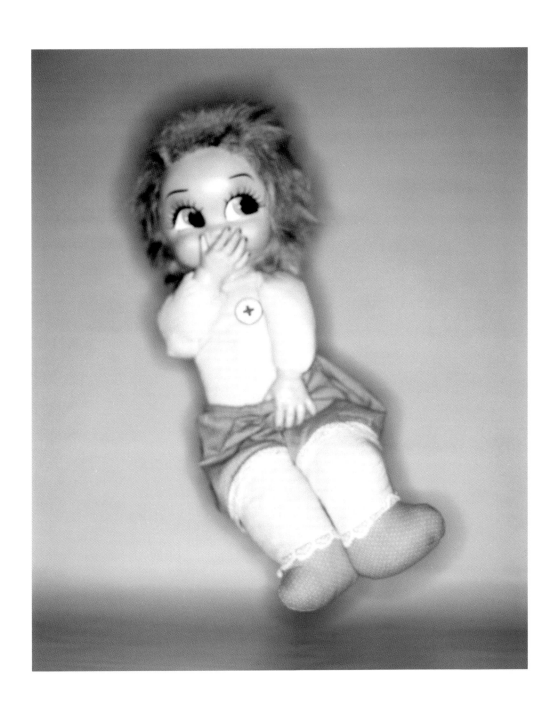

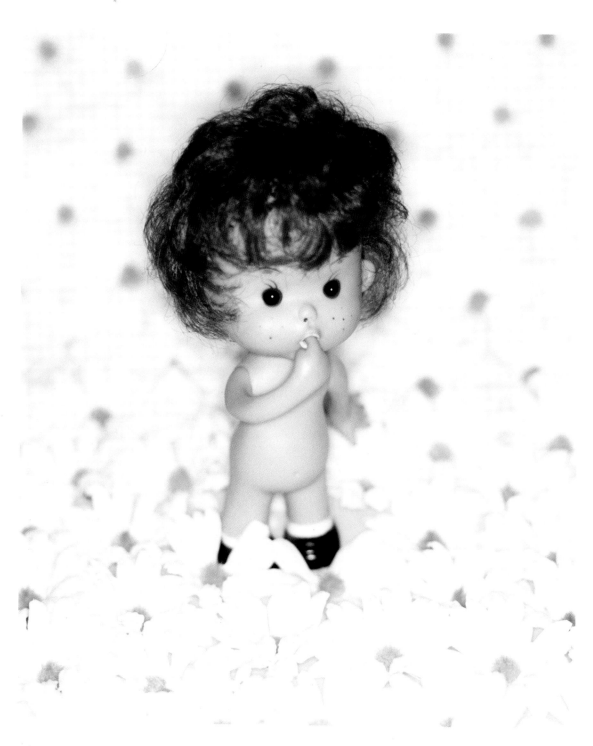

plate 26 **Daisy**
plate 27 **Dottie** >

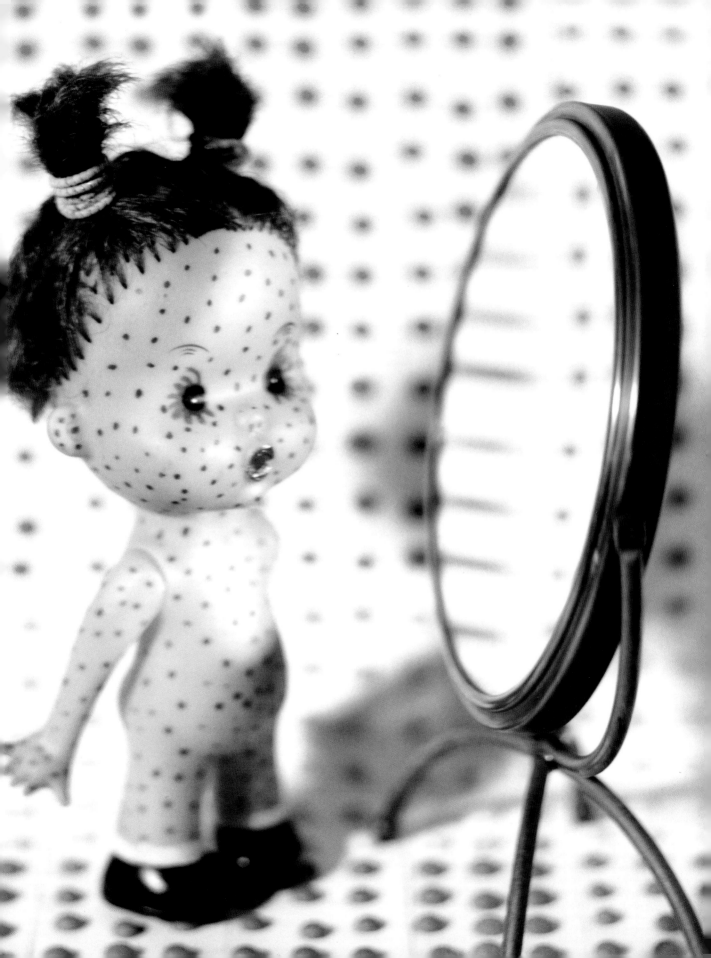

plate 28 **Star Baby** >

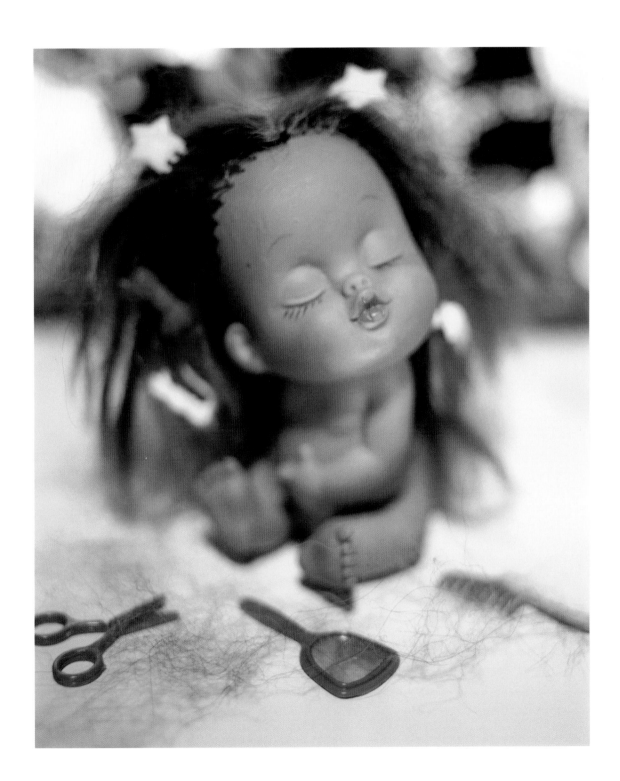

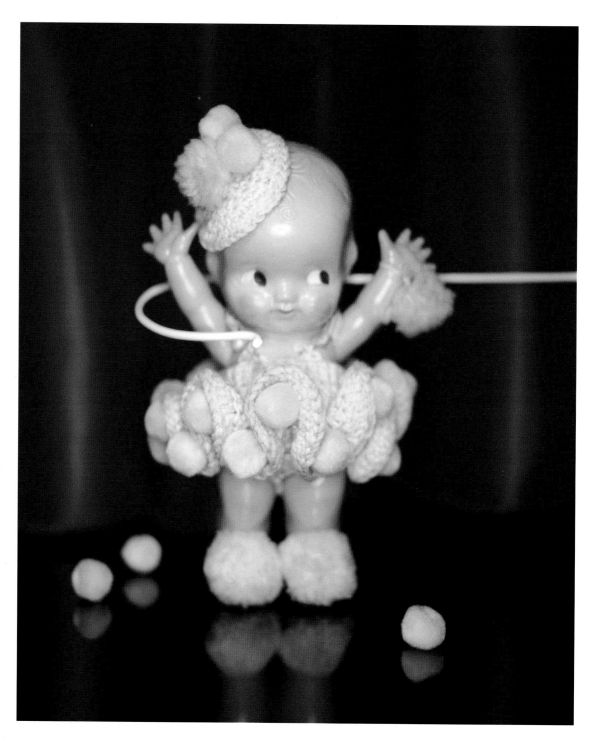

plate 29 **Competitive Girl**
plate 30 **Tack Boy** >

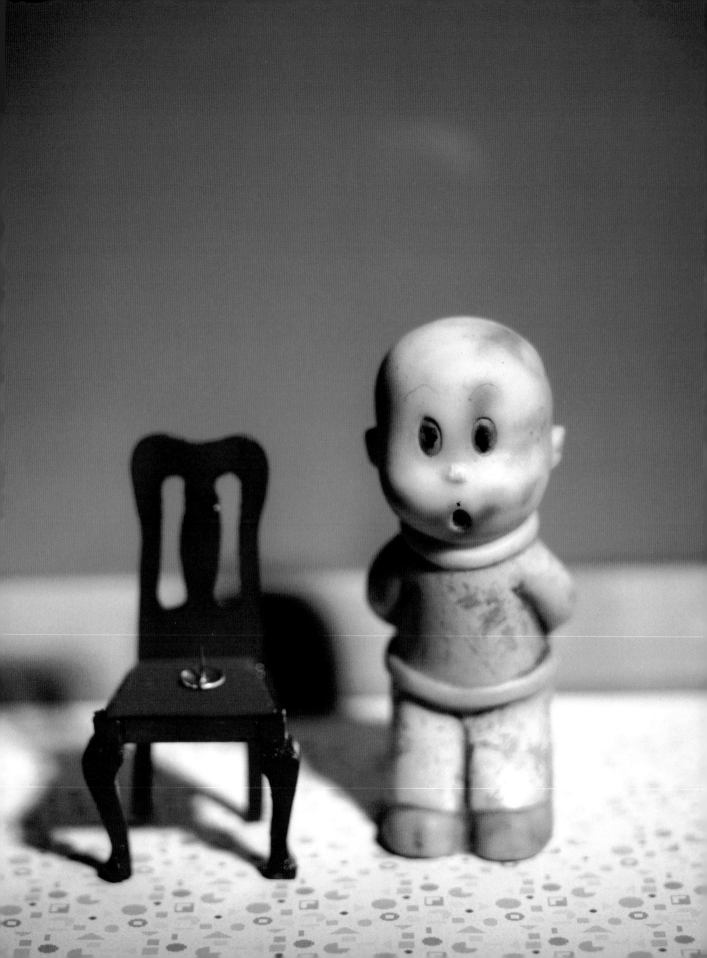

plate 31 **Dunce Boy** (Polaroid)
plate 32 **Tasty Boy** >

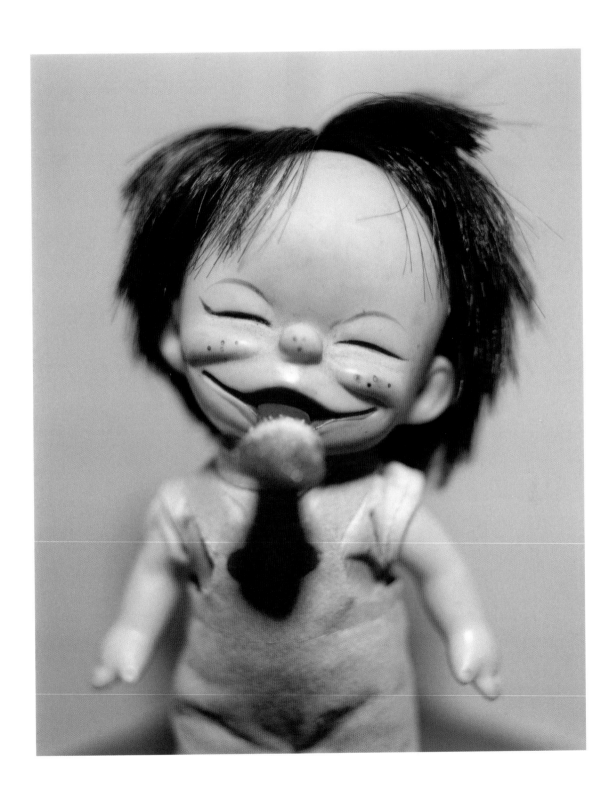

plate 33 **Island Boy** >

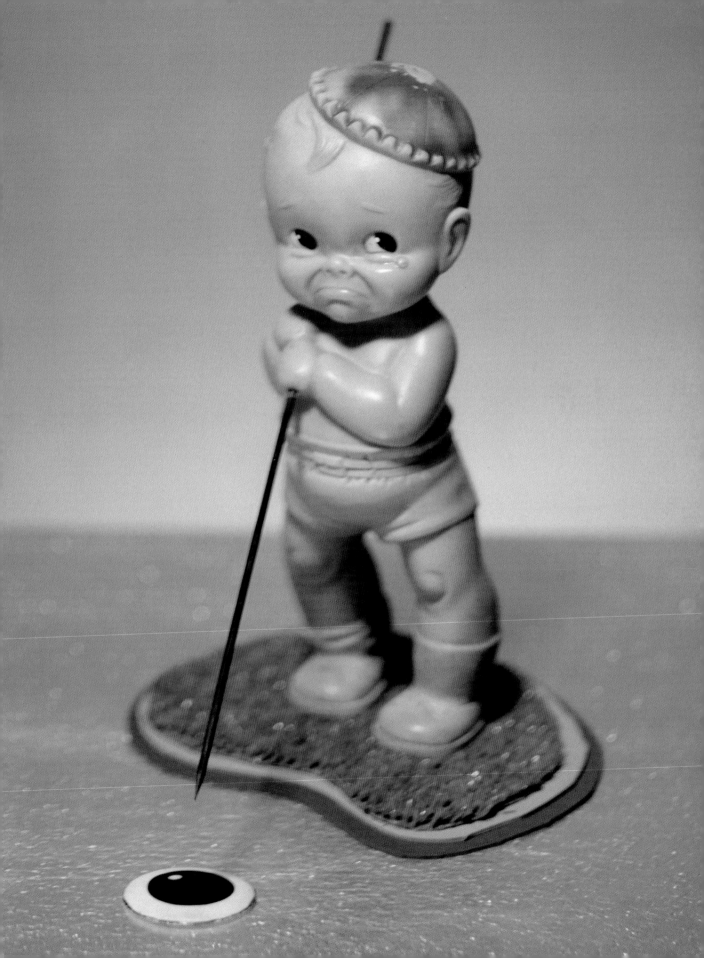

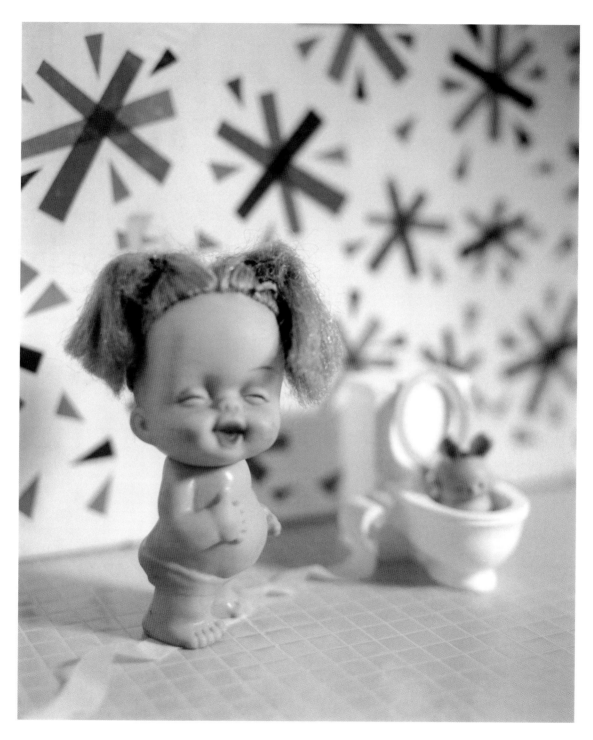

plate 34 **Bad Girl**
plate 35 **Beach Baby** >

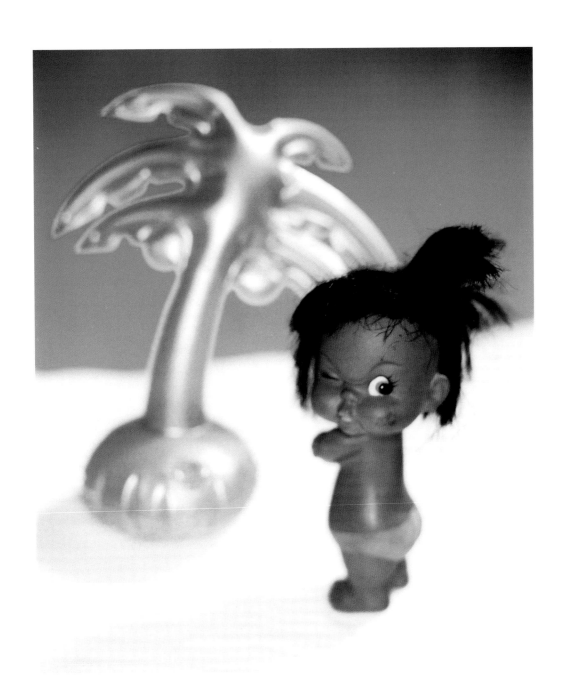

plate 36 **Big Mary, Little Mary** >

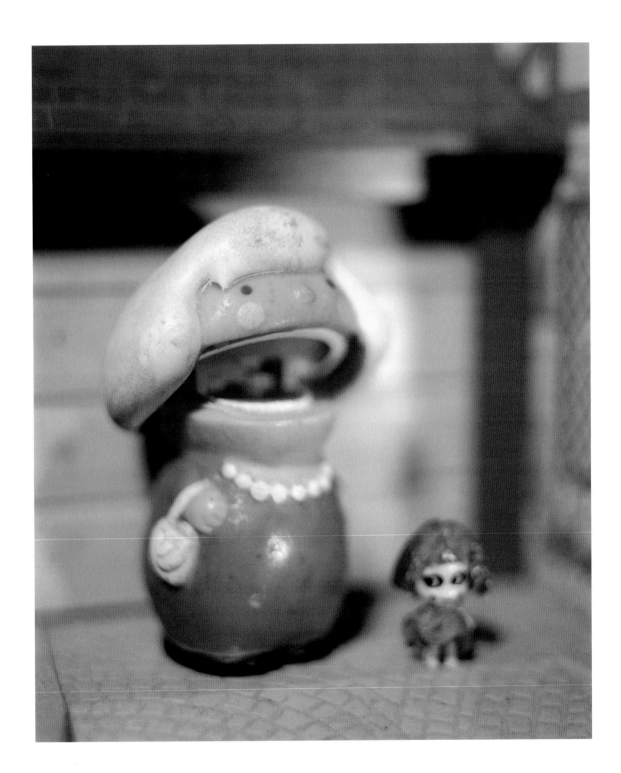

plate 37 **Yum Yum Girl** >

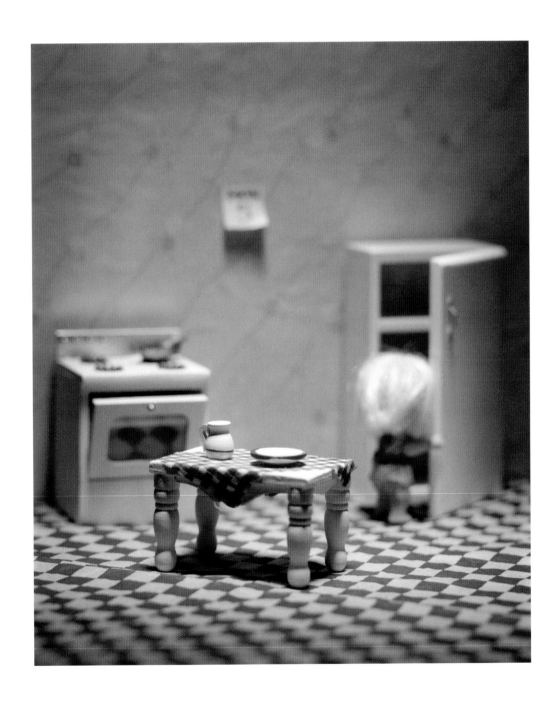

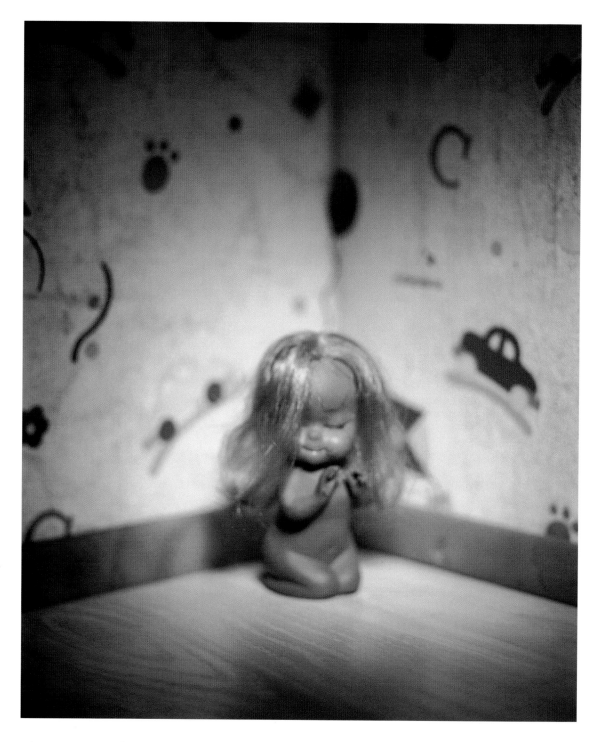

plate 38 **Angel**
plate 39 **Bend Over Boy** >

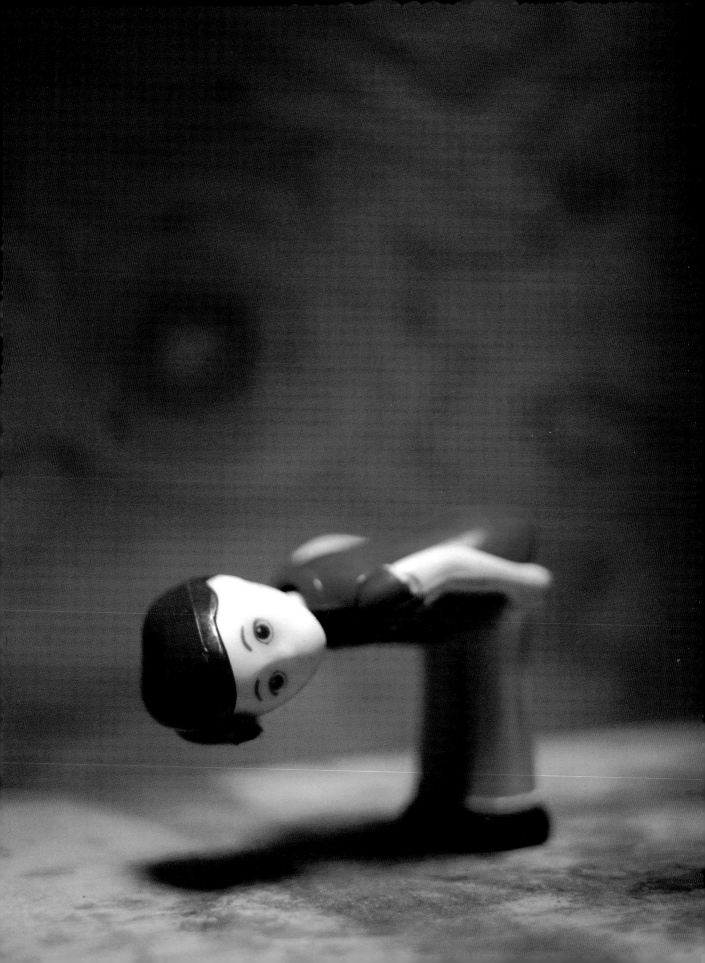

plate 40 **Tub Girl** >

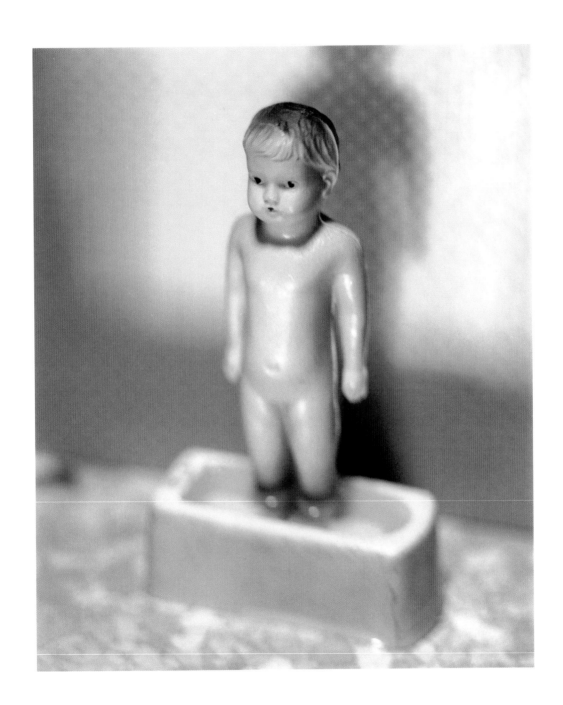

plate 41 **Bleach Baby** >

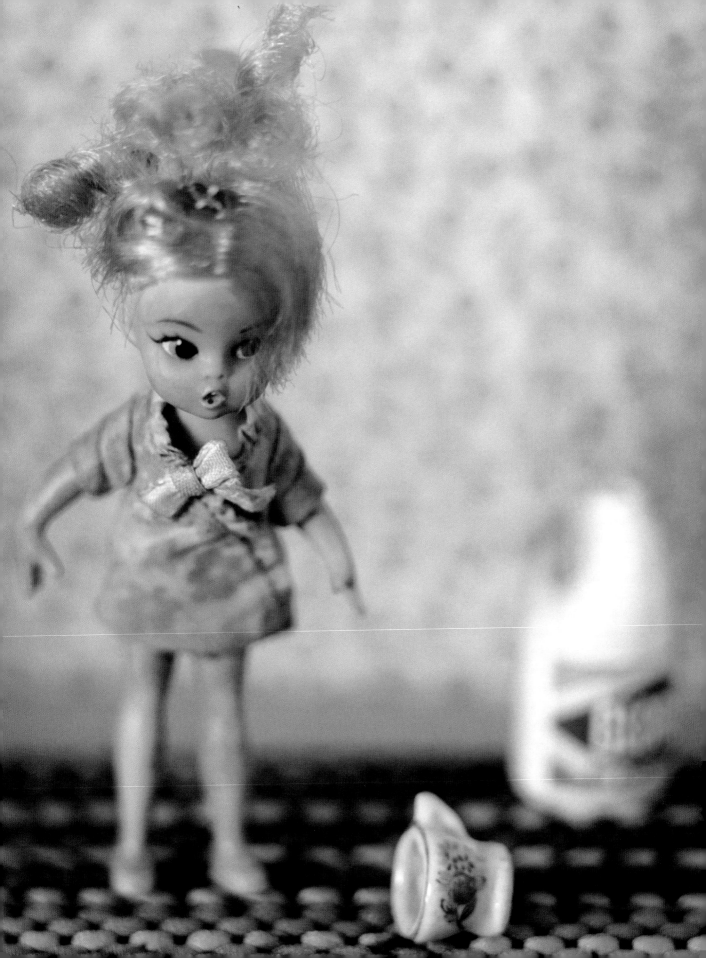

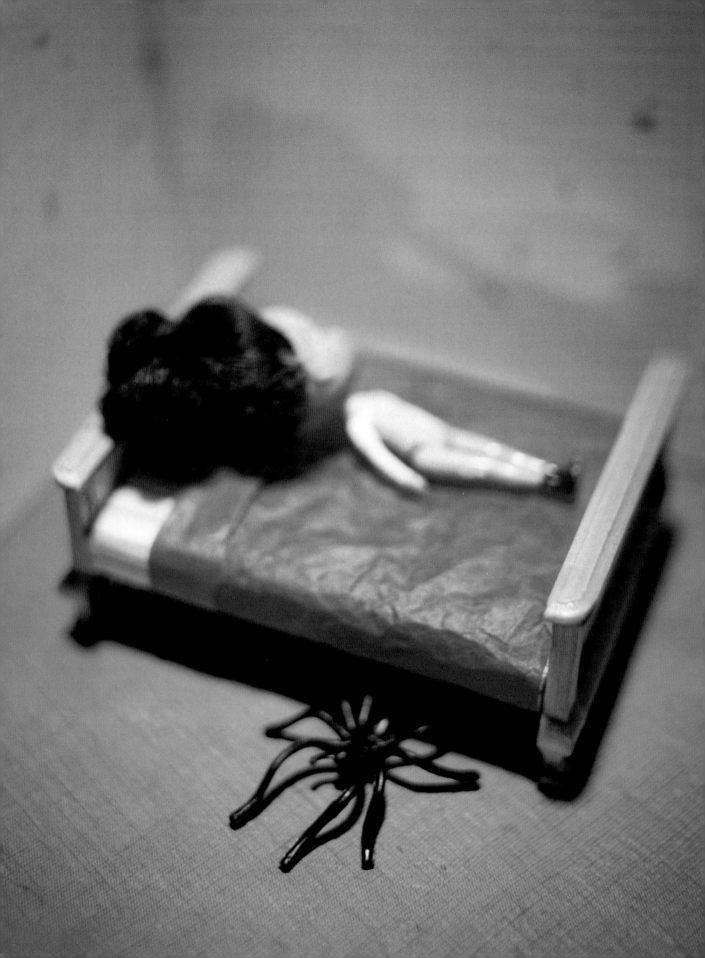

Swamp Girl plate 43
< **Spider Girl** plate 42

plate 44 **Tsunami Girls** >

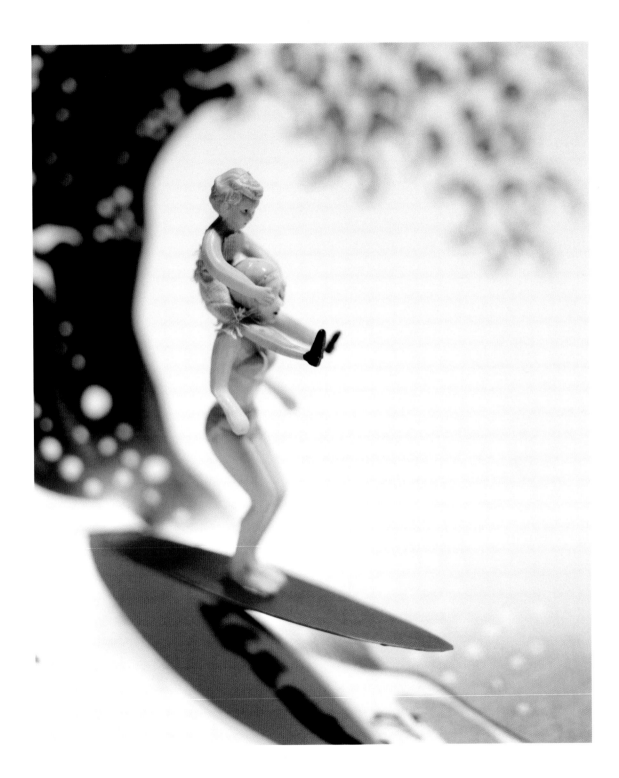

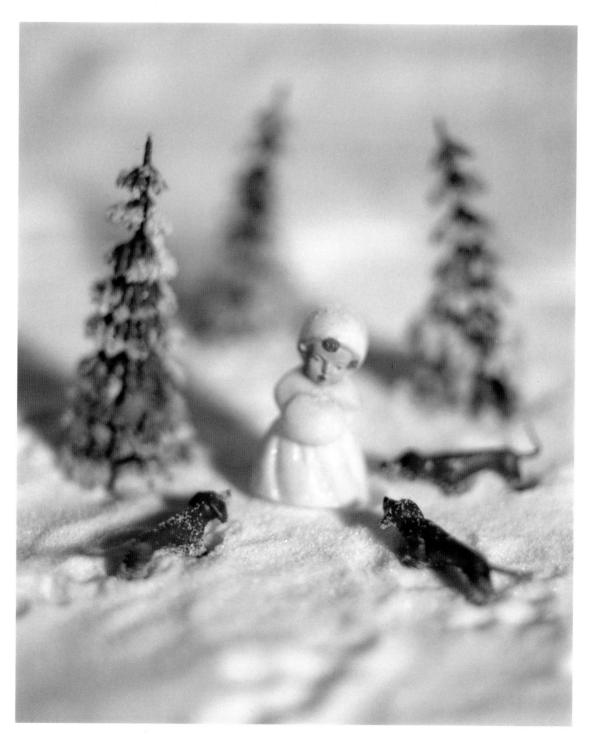

plate 45 **Muffy**
plate 46 **Whale Boy** >

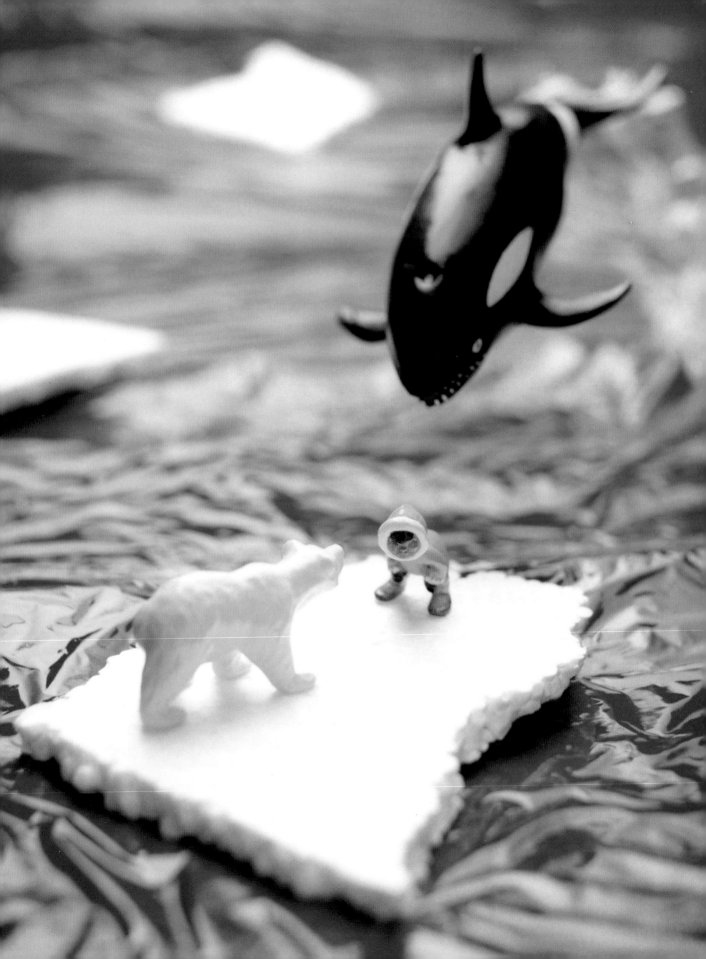

plate 47 **Roy Boy** >

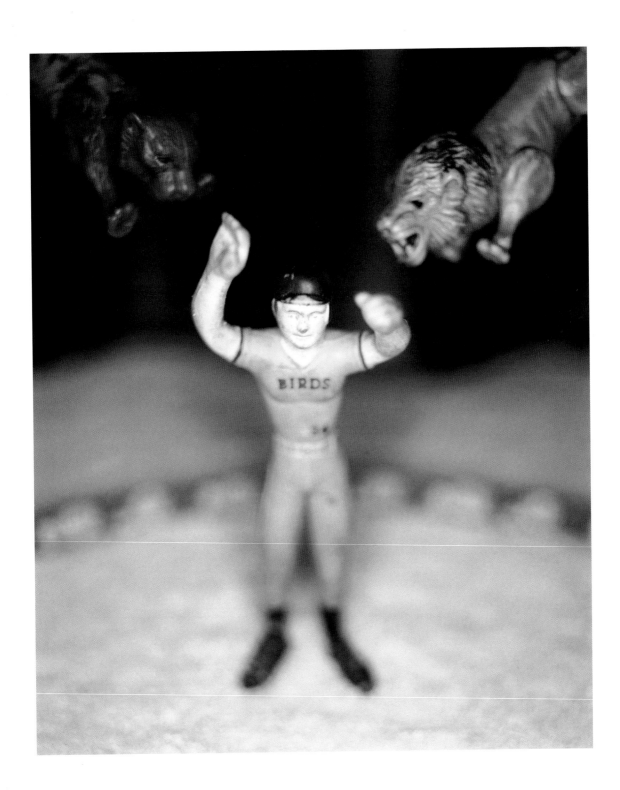

plate 48 **4H Boy** >

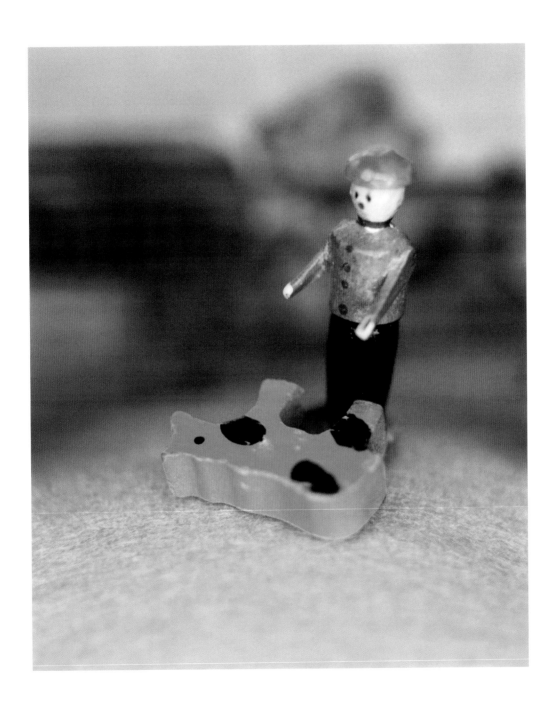

plate 49 **Wheel Boy** >

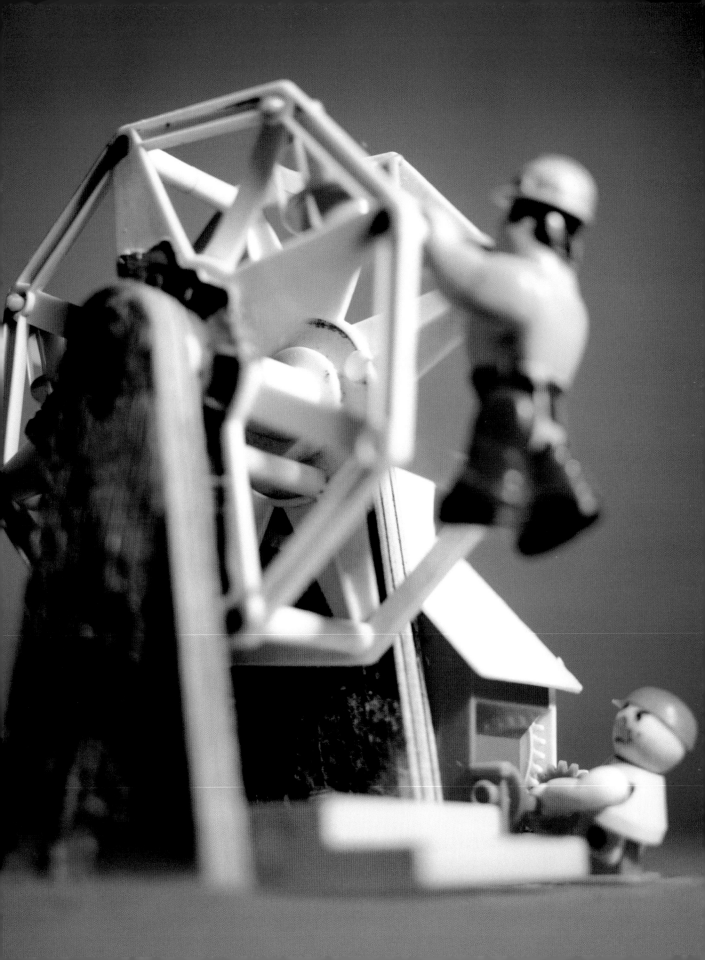

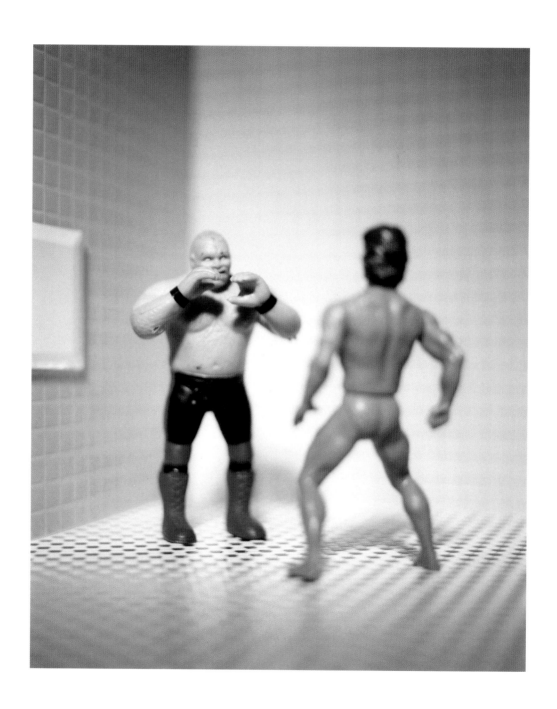

plate 50 **Big Boy**
plate 51 **Wrestlers** >

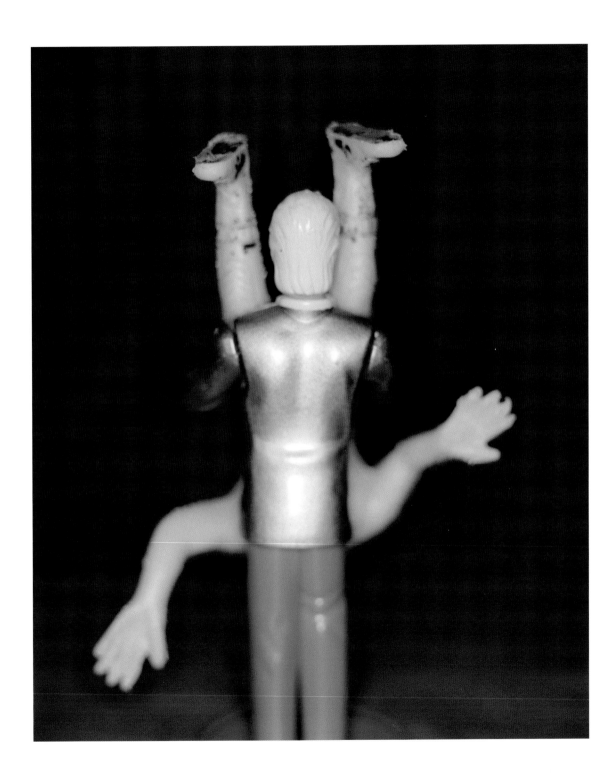

plate 52 **Shy Girl** >

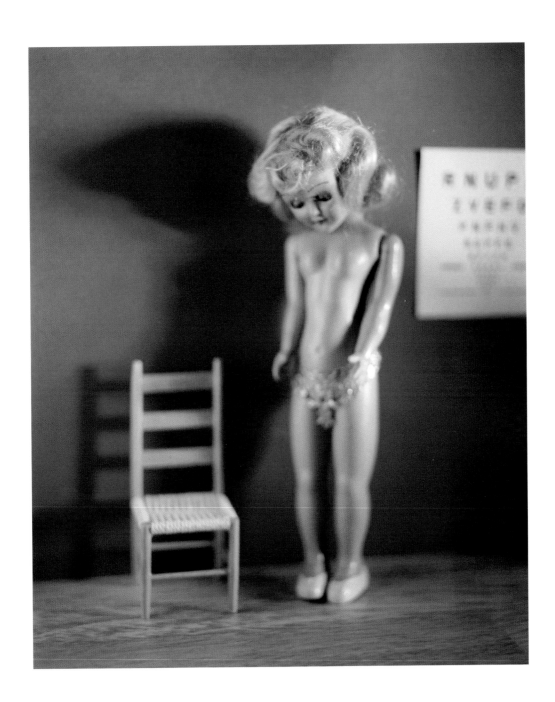

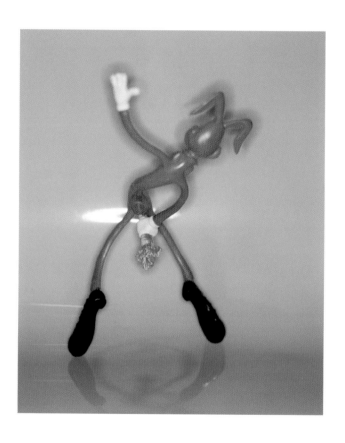

plates 53 - 55 **Bendy Bunny (Anal, Oral & Genital)** (triptych)

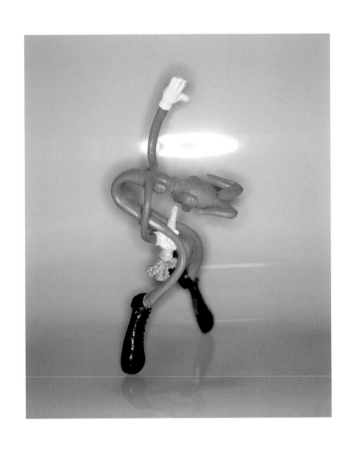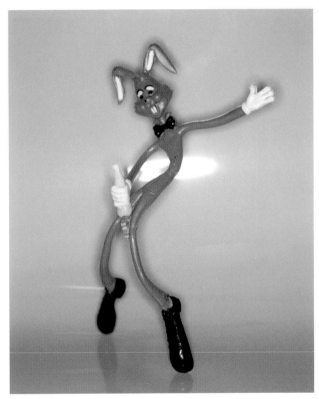

plate 56 **Heidi** >

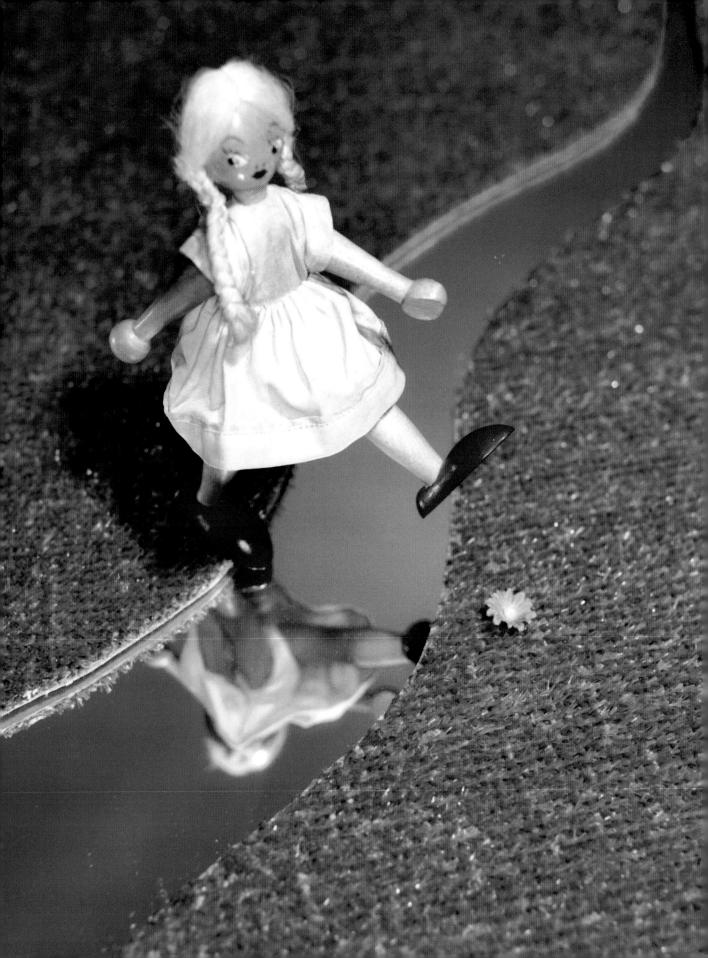

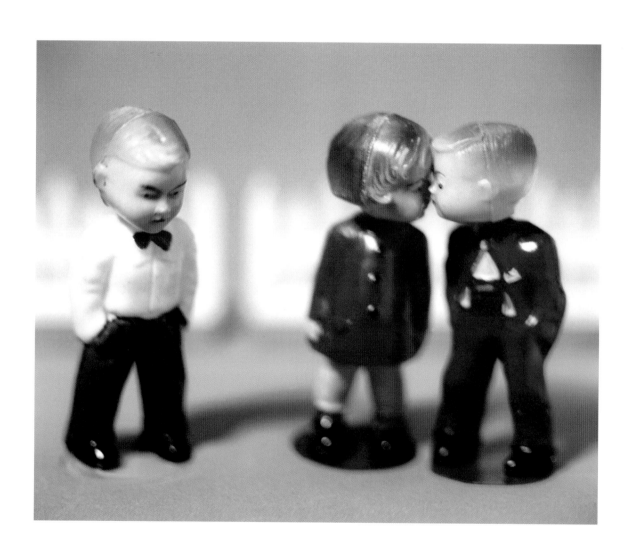

plates 57 - 58 **The Kissers** (diptych)

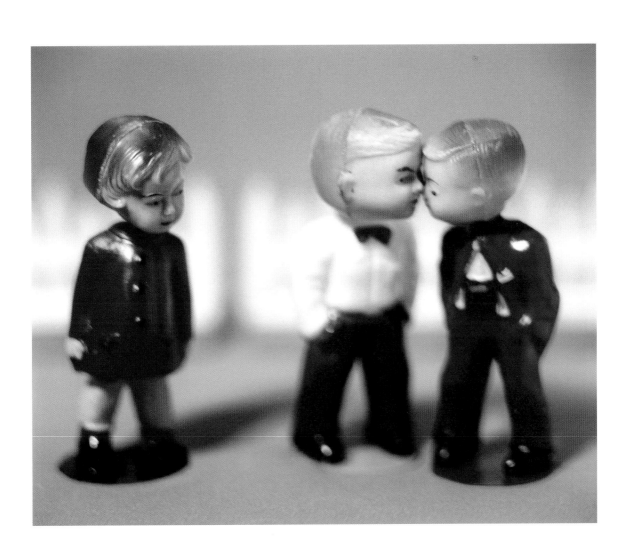

plate 59 **Banana Boy** >

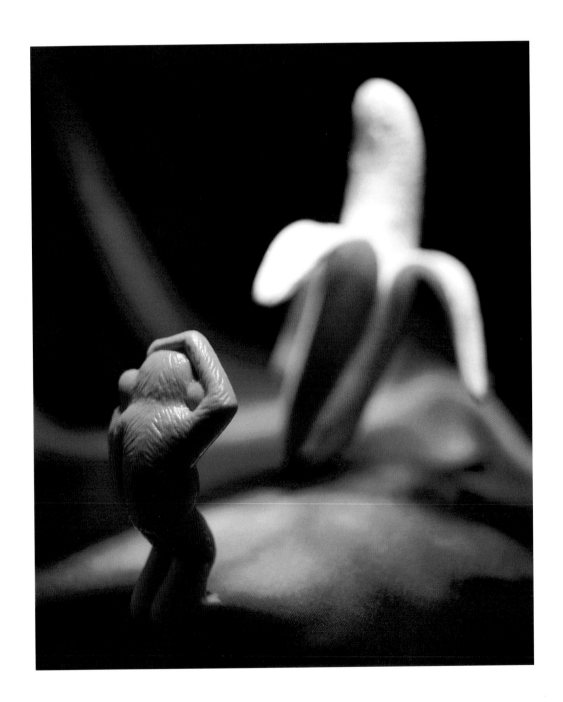

plate 60 **Worm Girl** >

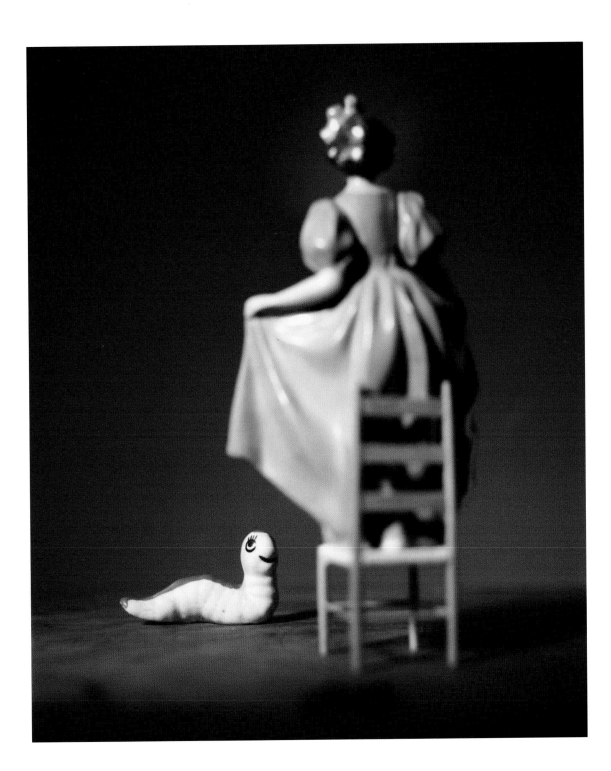

plate 61 **Candy** >

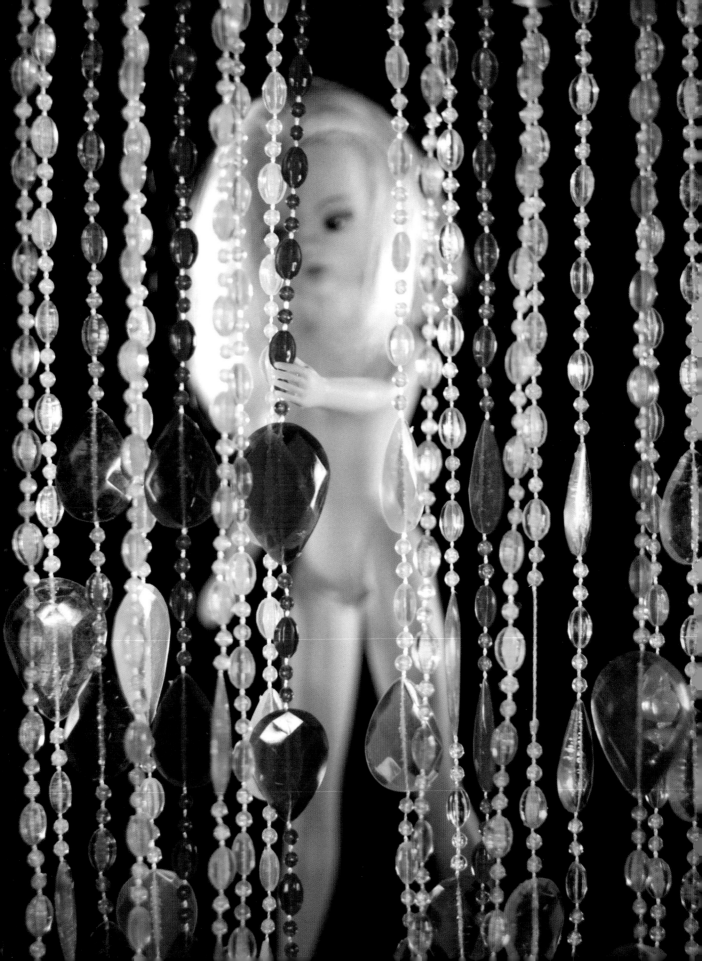

DAVIS & DAVIS have collaborated on a variety of photography, video, sculpture, and installation projects over the last twelve years. Their interests include cinema, psychology, pop culture, and fringe sciences. In addition to a recent solo show at the Heather Marx Gallery in San Francisco, Davis & Davis have exhibited at the Ulrich

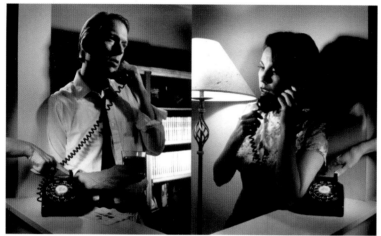

Museum of Art, the Yerba Buena Center for the Arts in San Francisco, the Downey Museum of Art, and the Huntington Beach Art Center, among other venues. Their work is in the collections of the Brooklyn Museum of Art, the Ulrich Museum of Art, California State University Los Angeles, California State Polytechnic University Pomona, Cypress College, and the Kinsey Research Institute as well as many private collections. Scott is an MFA candidate in Photography and Media at the California Institute of the Arts, where Denise earned her MFA in Photography. They are married and live in Los Angeles.

TYLER STALLINGS is a writer and the Curator of Exhibitions at the Laguna Art Museum. He has organized and written catalogue essays for several recent exhibitions including *Cyborg Manifesto, or The Joy of Artifice* (2001); *Surf Culture—The Art History of Surfing* (2002); and *Whiteness, A Wayward Construction* (2003). He is also the co-editor of *Uncontrollable Bodies: Testimonies of Identity and Culture* (Seattle: Bay Press, 1994).